PRAEGER

 $1.50

PAPERBACKS

PAUL KLEE

PEDAGOGICAL
SKETCHBOOK

Introduction and Translation by Sibyl Moholy-Nagy

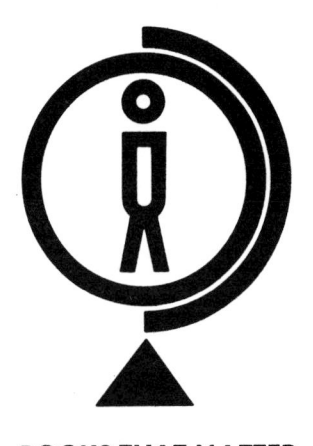

BOOKS THAT MATTER

PAUL KLEE

PEDAGOGICAL SKETCHBOOK

FREDERICK A. PRAEGER, *Publishers*
New York · Washington

BOOKS THAT MATTER

Published in the United States of America in 1960
by Frederick A. Praeger, Inc., Publishers
111 Fourth Avenue, New York, N.Y. 10003

Fourth printing, 1965

The original edition of this book
was published in 1953
by Frederick A. Praeger, Inc., New York.

This book by Paul Klee was first published
under the title Pädagogisches
Skizzenbuch 1925 as the second of the
fourteen Bauhaus Books edited by
Walter Gropius and Laszlo Moholy-Nagy.
The original layout by Laszlo Moholy-Nagy
has been retained. This edition was
composed at The Polyglot Press, New York,
by Peter Bergman.

Introduction and Translation
by
Sibyl Moholy-Nagy

INTRODUCTION
by Sibyl Moholy-Nagy

"For the artist communication with nature remains the most essential condition. The artist is human; himself nature; part of nature within natural space."*

This statement, written in 1923 by Paul Klee, was the Leitmotif of a creative life that derived almost equal inspiration from painting and from music. Man painted and danced long before he learned to write and construct. The senses of form and tone are his primordial heritage. Paul Klee fused both of these creative impulses into a new entity. His forms are derived from nature, inspired by observation of shape and cyclic change but their appearance only matters in so far as it symbolizes an inner actuality that receives meaning from its relationship to the cosmos. There is a common agreement among men on the place and function of external features: eye, leg, roof, sail, star. In Paul Klee's pictures they are used as beacons, pointing away from the surface into a **spiritual** reality. Just as a magician performs the miraculous with objects of utter familiarity, such as cards, handkerchiefs, coins, rabbits, so Paul Klee uses the familiar object in unfamiliar relationships to materialize the unknown.

The Symbolic Expressionists and the Cubists during the first decade of the Twentieth Century had already questioned the validity of Academic Naturalism. Their painting had looked below the surface with the analytical eye of psychology and x-ray. But the multi-layered figures of Kirchner and Kokoschka or the simultaneous views of Braque and Picasso, were analytical—**statements**, resting statically on the canvas. Klee's figures and forms are not only transparent, as if seen through a fluoroscope; they exist in a magnetic field of cross currents: lines, forms, splotches, arrows, color waves. As if it were a symphonic composition, the main motif moves from variation to variation in its relationship to other objects on the canvas. A bird in THE TWITTERING MACHINE, for instance, is different from all other birds through its relationship to transmision belt, crank shaft, and musical notations, floating in the air. Without contradicting himself, Klee could confess to "communication

* Quotations in this introduction are from Paul Klee, *Paths of the Study of Nature* (Wege des Naturstudiums). Yearbook of the Staatliche Bauhaus, Weimar, 1919-1923, Bauhaus Verlag, Weimar-Muenchen; and from the *Pedagogical Sketchbook.*

with nature" as the essence of his work, but he could also say that "all true creation is a thing born out of nothing." The seeming contrast is resolved through his unfailing originality "born out of nothing" which is the spiritual cause. The optical effect is a pictorial composition that uses the identifiable natural shape as mediary. In THE ROOM AND ITS INHABITANTS from 1921, floor boards, window frame and door, are recognizable, together with the faces of woman and child. But they are mere points of reference in a world of lines, arrows, reflections, fade-outs that reveal intuitively the mysterious man-shelter relationship that has determined the course of civilization.

If ever an artist understood the visual aspirations of his epoch it was Paul Klee; and the civilized world came to recognize his contemporane-ousness even before his death in 1940. Exhibitions and publications have constantly increased in number; and it might be assumed that, together with Cezanne and Picasso, he will be the most reproduced and annotated painter of this century. But it is known to few that Paul Klee was more than a painter. His "communication with nature" produced much more than the transfiguration of the perceived form. It produced a philosophy that rested on empathy with the created world, accepting everything that is with equal love and humility. As a very young man he had spoken of his art as **"andacht zum kleinen"** (devotion to small things). In the Microcosm of his own visual world he worshipped the Macrocosm of the universe. This was his revolution. Academic art had been based since the Renaissance on the Aristotelian principle of de-duction, meaning that all representation was deduced from the broad general principles of absolute beauty and conventional color canons. Paul Klee replaced deduction by **induction.** Through observation of the smallest manifestation of form and interrelationship, he could conclude about the magnitude of natural order. Energy and substance, that which moves and that which is moved, were of equal importance as symbols of creation. He loved the natural event; therefore he knew its meaning in the universal scheme. And with the instinct of the true lover he had to comprehend what he loved. The phenomenon perceived and analyzed, was investigated until its significance was beyond doubt. It is in Paul Klee that science and art fuse. **Exactitude winged by intuition** was the goal he held out for his students.

Paul Klee the painter could not help becoming a teacher in the original meaning of the term. The word "to teach" derives from the Gothic "taiku-sign" (our word token). It is the mission of the teacher to observe

8

what goes unnoticed by the multitude. He is an **interpreter of signs.** When Walter Gropius developed the curriculum of his German Bauhaus, he gave back to the word teacher its basic significance. Kandinsky, Klee, Feininger, Moholy-Nagy, Schlemmer, Albers, who taught there, were interpreters of the visual as tokens of a fundamental optical and structural order that had been obscured by centuries of literary allegorism. In this community of guides Paul Klee chose for himself the task of pointing out new ways of studying the signs of nature. "By contemplating the optical-physical appearance, the ego arrives at intuitive conclusions about the inner substance." The art student was to be more than a refined camera, trained to record the surface of the object. He must realize that he is "child of this earth; yet also child of the Universe; issue of a star among stars."

A mind so in flux, so sensitive to intuitive insights, could never write an academic textbook. All he could retain on paper were indications, hints, allusions, like the delicate color dots and line plays on his pictures. The PEDAGOGICAL SKETCHBOOK is the abstract of Paul Klee's inductive vision. In it the natural object is not merely rendered two-dimensionally, it becomes "räumlich," related to physical and intellectual space concepts, through four main approaches that form the four divisions of the Sketchbook:

> Proportionate Line and Structure
> Dimension and Balance
> Gravitational Curve
> Kinetic and Chromatic Energy

The first part of the Sketchbook (Sections I.1-I.13) introduces the transformation of the static dot into linear dynamics. The line, being successive dot progression, walks, circumscribes, creates passive-blank and active-filled planes. Line rhythm is measured like a musical score or an arithmetical problem. Gradually, line emerges as the measure of all structural proportion, from Euclid's **Golden Section** (I.7) to the energetic power lines of ligaments and tendons, of water currents and plant fibers. Each of the four divisions of the Sketchbook has one key-sentence, strewn almost casually—without the pompousness of a theorem—among specific observations. This one sentence in each chapter points the path from the particular to the universal. The first part on "Proportionate Line and Structure" is condensed into one laconic statement:

"purely repetitive and therefore structural" (I.6), explaining in five words the nature of vertical structure as the repetitive accumulation of like units.

The second part of the Sketchbook (II.14-II.25) deals with "Dimension and Balance." Here the object, rendered by line, is related to the subjective power of the human eye. Man uses his ability to move freely in space to create for himself optical adventures. What are railroad ties? Functional cross-beams, occurring at regular intervals. Yes, but they are also subdivisions of infinite space, capable of bisecting the third dimension at a hundred different angles (II.15). Man, precariously balanced on two unstable legs, uses optical illusion as a safety device. Horizon as concrete fact, and horizon as an imaginary safety belt that has to be **believed in**, are exemplified on the graceful example of the tightrope walker and his bamboo pole (II.21). The purely material balance of the scale finds its counter-part in the purely psychological balance of light and dark, weightless and heavy colors (II.24). The key word to this section reads: "non-symmetrical balance" (II.23). It asserts that "the bilateral conformity of two parts" which is the old definition of symmetry, has been superseded by "the equalization of unequal but equivalent parts."* Dimension is in itself nothing but an arbitrary expansion of form into height, width, depth and time. It is the balancing and proportioning power of eye and brain that regulate this expansion of the object toward equilibrium and harmony.

The third aspect of the study of nature in the Sketchbook (III.26-III.32) deals with the tension existing between man's ability to project himself and the object into space, and the limitations imposed upon this urge by the gravitational pull. The **linear** extension of the first section of the book, and the balance of **dimensional** form in the second section, is **here** followed up with the **projection** of motion above and below the horizon of the human eye. The plump line (III.26) is man's umbilical cord to the center of the earth. It symbolizes the tragic termination of his will to fly, but it also symbolizes firmness and rhythm and the assuring direction toward rest. The falling stone, the ascending flier, the shooting star on the firmament (III.30-32) are natural dynamics whose course is decided by the gravitational curve. "But," Klee concludes, "there are regions with different laws and new symbols, signifying freer movement and more dynamical position." With this mere hint (III.26) at the existence of purely **spiritual** dynamism, that supersedes the phenomenal

* Piet Mondrian

world and its earthbound fate, Klee defines his Naturalism as a symbolism of great depth. The core of this third section, which is a transition from observation to intuition, is defined in the axiom that is perhaps Klee's deepest wisdom:

TO STAND DESPITE ALL POSSIBILITIES TO FALL!

The concluding chapter (IIII.33-43) allows the student a glimpse at the forces that create optical sensation, forces that are either kinetic-mobile, or chromatic-caloric. Plato spoke of EIDOS as the inner essence of an object as distinguished from the apparent outer form; and Aristotle uses the term ENTELECHY when he defines the form-giving cause that manifests an idea in a material configuration. True to his inductive creed, Paul Klee demonstrates inner essence and form-giving cause on the most insignificant objects, the spinning top, for instance (IIII.33) that defies gravity by the centrifugal energy of its gyrations, or the feathered arrow (IIII.37) whose path is hampered by gravitational friction. "To be impelled toward motion, and not to be the motor!" Thought and intention that send the arrow on its way are identified with the supra-mechanical force of the Eidos. With the ease of the perfect dancer who has sublimated his intense effort into seeming play, Paul Klee presents his new naturalism through an interchange of natural phenomenon and pure idea. The proportionate relationship of point and rudder to shaft in the **actual** arrow (IIII.38) is calculated on a strictly mechanical basis. But the same exactitude is applied in calculating the orbit of the **symbolic** arrow, overcoming the friction of human fear by aiming "a bit farther than customary—farther than possible!" The final decision rests with man's willingness to produce energy. "The stronger the pull of the ascension rudder, the higher the rise; the stronger the pull of the drop rudder, the steeper the fall."

Energy, the Sketchbook concludes, is without termination only in the chromatic and thermo-dynamic field. Motion that may be called infinite in the sense of unending self-transformation, exists only in the activation of color, moving between the fervid contrasts of utter black and utter white (IIII.40) with the thermo-dynamic implications of intense heat and extreme cold. The last six diagrams complete the cycle that had started on page one when the dot was stirred from its static existence into line progression. On its way through the Sketchbook it has

11

been transformed by the counter forces of earth and world, of mechanical law and imaginative vision, and it has found equilibrium in a centrality that no longer points away but rests within a unified diversity (IIII.43). The sum total is what Paul Klee calls "Resonanzverhältnis," meaning a reverberation of the finite in the infinite, of outer perception and inner vista. The experience of this dual reality of the SEEN and the FELT essence of nature, impells the student toward

> "a free creation of abstracted forms which supersede didactic principles with a new naturalness, the naturalness of the work. He produces or participates in the production of works which are indications of the work of God."

Paul Klee

An **active** line on a walk, moving freely, without goal. A walk for a walk's sake. The mobility agent is a point, shifting its position forward (Fig. 1):

Fig. 1

The same line, accompanied by complementary forms (Figs. 2 and 3):

Fig. 2

Fig. 3

16

The same line, circumscribing itself (Fig. 4):

Fig 4

Two secondary lines, moving around an imaginary main line (Fig. 5):

Fig. 5

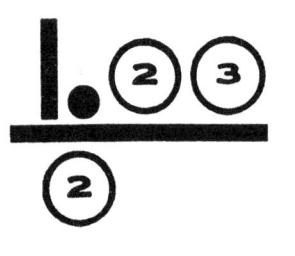

An **active** line, limited in its movement by fixed points (Fig. 6):

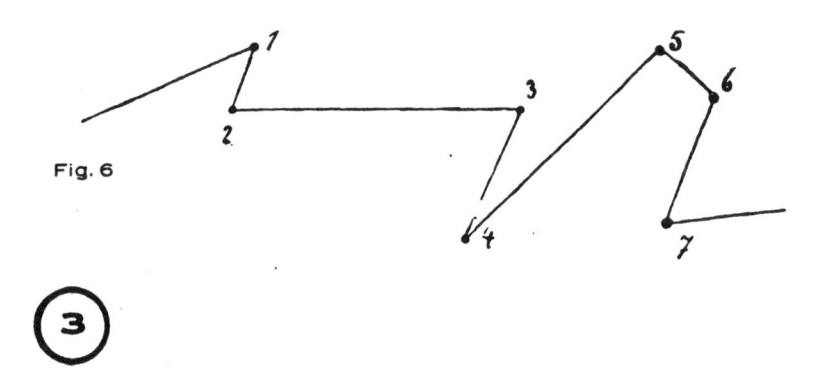

Fig. 6

A **medial** line which is both: point progression and planar effect (Fig. 7):

In the process of being created, these figures have linear character; but once completed, this linearity is replaced by planarity.

Fig. 7

18

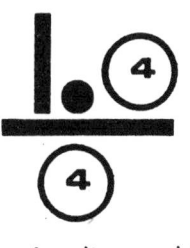

assive lines which are the result of an activation of planes (line pro-
ression) (Fig. 8):

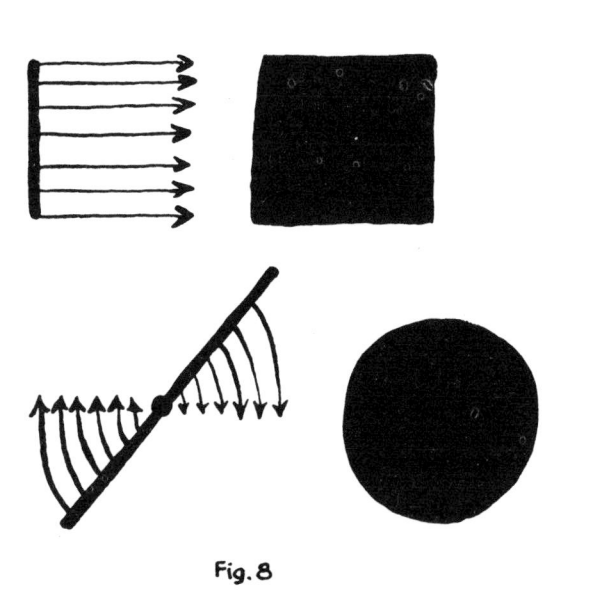

Fig. 8

Passive angular lines and passive circular lines become active as planar
constituents.

5 Summary (Figs. 9-12):

FIRST CASE:

Fig. 9 Fig. 9a. Fig. 9b.

Active lines, passive planes; linear energy (cause), linear impact (effect), secondary planar effect.

SECOND CASE:

Fig. 10

Medial lines; linear energy (cause), planar impact (effect).

THIRD CASE:

Fig 11

Active planes, passive lines; planar energy (cause), planar impact plus secondary linear effect.

20

1.⑤

THREE CONJUGATIONS:

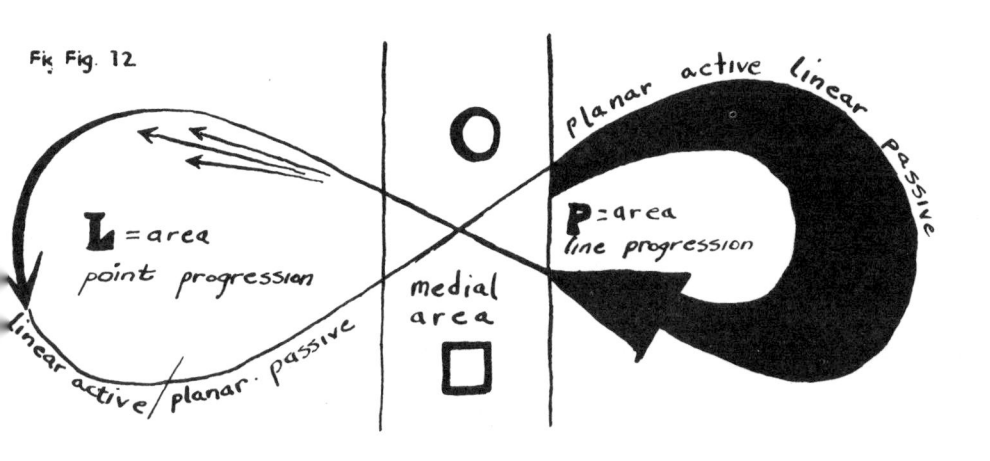

Fig Fig. 12

Semantic explanation
of the terms active, medial, and passive:

active: I fell (the man fells a tree with
his ax).
medial: I fall (the tree falls under the ax
stroke of the man).
passive: I am being felled (the tree lies
felled).

(Divisional Articulation.)

Fig. 13: The most primitive structural rhythm based on a repetition of the same unit from left to right, or top to bottom.

Fig. 14: Very primitive structural rhythm in double motion top to bottom and left to right.

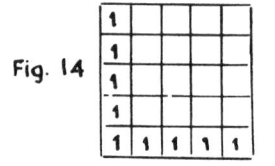

Fig. 14

Fig. 15: This rhythm is more complex. Its theme is: one plus two $(1 + 2)$.

$1 + 2 + 1 + 2$ in metric presentation

$1 + 2 + 1 + 2$ in stress presentation

If $1 + 2 + 1 + 2$ are replaced by $(1 + 2) + (1 + 2)$ it equals $3 + 3 + 3 + 3$ which amounts to another repetition of the basic theme.

QUANTITATIVE STRUCTURE, moving to two dimensions.

(The Chessboard)

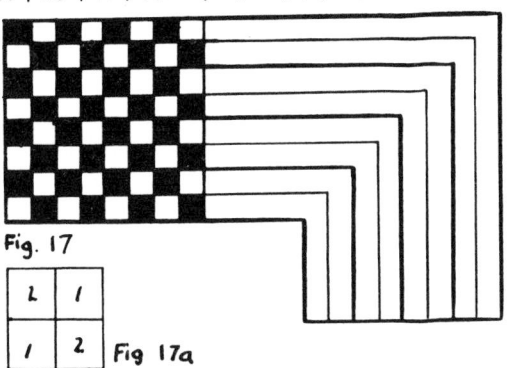

Fig. 16

Horizontal and vertical sums (Fig 16):
$11 + 10 + 11 + 10 + 11 + 10 = (11 + 10) + (11 + 10) + (11 + 10) = 21 + 21 + 21 = I + I + I.$

Fig. 17

Fig 17a

Fig. 17: If one considers section 17a as a unit with 6 values, one arrives at the following numerical presentation of Fig. 17:

purely repetitive and
therefore structural.

$6+6+6+6 = I \quad I \quad I \quad I$
$+ \quad + \quad + \quad +$
$6+6+6+6 = I \quad I \quad I \quad I$
$+ \quad + \quad + \quad +$
$6+6+6+6 = I \quad I \quad I \quad I$
$+ \quad + \quad + \quad +$
$6+6+6+6 = I \quad I \quad I \quad I$

23

Fig. 18: Both dimensions combined, seen diagonally.

Fig. 18:

Fig. 19: Linear variation.

Since these figure arrangements resf on the principle of repetition, any number of parts can be added or taken away without changing their rhythmic character.

$$I + I + I,\ \Big|\ I + I + I + I +\ \Big|\ I + I + I + I + I\ \cdot\ \Big|\ etc$$

Fig. 20 $\underset{=}{}^{3}/_{3}$ *as divisional rhythm* $= {}^{4}/_{4}$ *as divisional rhythm* $= {}^{5}/_{5}$ *as divisional rhythm* $= {}^{6}/_{6}$ *etc* **Therefore the structural character is divisional.**

 Individual Articulation.

In contrast to structural units, individual (or abstract) numerical divisions cannot be reduced to I, but must stop at proportions

such as 2:3:5
or 7:11:13:17
or a:b = b: (a + b) (Golden Section).

⑧ Material Structure.
in nature.

Bones

Tendons

Muscle.

Fig. 21

Structural concept in nature:

The grouping of the smallest recognizable entities in matter:

Bone matter is cellular or tubular.

Ligament structure is a sinuous-fibrous web.

Tendons are continuous with the connective tissue of the muscle, strengthened by cross grain.

⑨ **The natural organism of movement as kinetic will and kinetic execution (supra-material).**

A Bones are coordinated to form the skeleton.

Even at rest they depend on mutual support.

This is furnished by the ligaments.

Theirs is a secondary function; one could speak of a hierarchy of function.

The next step in motoric organization leads from bone to muscle. The tendon is the mediary between these two.

Fig 22

Fig. 23.

B And what is the relationship of muscle to bone?

Through its ability to contract or shorten itself, the muscle brings two bones into a new angular relationship.

If one considers further the realm of kinetic organisms, one comprehends in the relationship of bone to muscle the mediary function of the tendon.

The position of two bones toward each other **must** change if the muscle so decides.

Muscle function supersedes bone function; in relationship to muscle function, the bone function is **passive.**

Bones give support to the total organism; also when in motion.

Muscles have a higher function because they act beside each other.

One bends, the other stretches.

One bone alone achieves nothing.

C The independence of the muscle function is, of course, relative. It applies only in relationship to bone function. Actually the muscle is not independent but obeys orders, issued from the brain. It does not want to act; or, at best, it wants to obey. The transmission of a brain order can be compared to a telegram, with nerves acting as wires.

In order to visualize the relative interrelationship of serving and commanding, or of structural to individual function, Fig. 24 presents a diagram comparable to nesting toy boxes.

Fig 24

* This diagram employs an arrangement according to weight or importance, with increased values toward the center; in an arrangement according to measurement, the brain would have to occupy the (peripheral) place of the greatest spatial expansion, and the position of the motoric faculties would be reversed.

(based on the Trichotomy):

> First organ active (brain).
> Second organ medial (muscle).
> Third organ passive (bones).

a) **Waterwheel and Hammer** (Fig. 25):

Fig. 25

I The Waterfall (active). II Wheels (medial). II Hammer (passive).

Drums of the big wheel. Spokes of the small wheel.

Transmission belt.

30

b) **The Watermill** (Fig. 26):

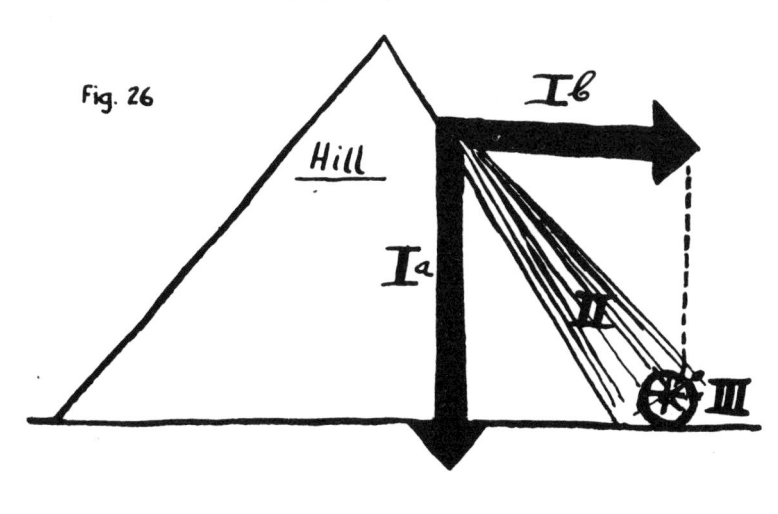

I Two energies: a) gravity, b) the obstructing mountain (active).

II Diagonal force to energies 1a and 1b: The Waterfall (medial).

III The turning wheel (passive).

c) **The plant** (Fig. 27):

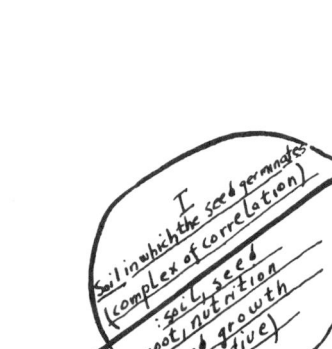

III blossom (passive)

II respiratory organs in light and air (Leaves) (medial)

I Soil in which the seed germinates (complex of correlation) soil, seed root, nutrition and growth (active)

Fig. 27

d) (not illustrated) Propagation:

 I Male organs (anthers), active

 II Pollen-carrying insects, medial.

 III Female organs (fruit), passive.

e) **Circulatory System** (Fig. 28):

 I The heart pumps (active).

 III The blood is moved (passive).

 II The lungs receive blood and participate in sending it on transformed (medial).

 I The heart pumps.

 III The blood again is moved and returns to the heart, its point of departure.

Fig. 28

32

Productive **Receptive**

Productive	Receptive
The work grows "stone upon stone" (additive) or The block is hewn "chip from chip" (subtractive) Both processes, building and reducing, are time-bound.	

Fig. 29

Already at the very beginning of the productive act, shortly after the initial motion to create, occurs the first counter motion, the initial movement of receptivity. This means: the creator controls whether what he has produced so far is good.

The work as human action (genesis) is productive as well as receptive. It is **continuity**.

Productively it is limited by the manual limitation of the creator (who has only two hands).

Receptively it is limited by the limitations of the perceiving eye. The limitation of the eye is its inability to see even a small surface equally sharp at all points. The eye must "graze" over the surface, grasping sharply portion after portion, to convey them to the brain which collects and stores the impressions.

The eye travels along the paths cut out for it in the work.

33

II.

Dimensions

2

1

Fig. 30

3

1. Dimension: left (right)
2. Dimension: top (bottom)
3. Dimension: front (back)

Twodimensional:

a) Two parallel lines, seen frontally by the eye:

b) Railroad tracks, seen frontally:

c) Two parallel lines, seen from a deflected angle of vision

The third dimension added as optical illusion.

Fig. 31

d) Railroad tracks, seen sideways, with ties serving as measure of the perspective progression from rear to front (Fig. 32):

Fig. 32

e) Figure 32 seen frontally (Fig. 33):

Fig. 33

 Operation in three dimensions (Fig. 34):

Fig. 34

(17) **Verticality.**

Fig. 35: Railroad ties, seen frontally. A distant and a close tie are subdivided equally.

Fig. 36: The perspective progression visualized through lines running parallel to the tracks. Emphasis on the frontal plump line (perpendicular to the ties).

Fig. 35 Fig 36

Shifting vertical axis in relation to a subject (spectator) moving left to right.

Fig. 37: The subject has moved toward left.

Fig. 38: The subject has moved toward right.

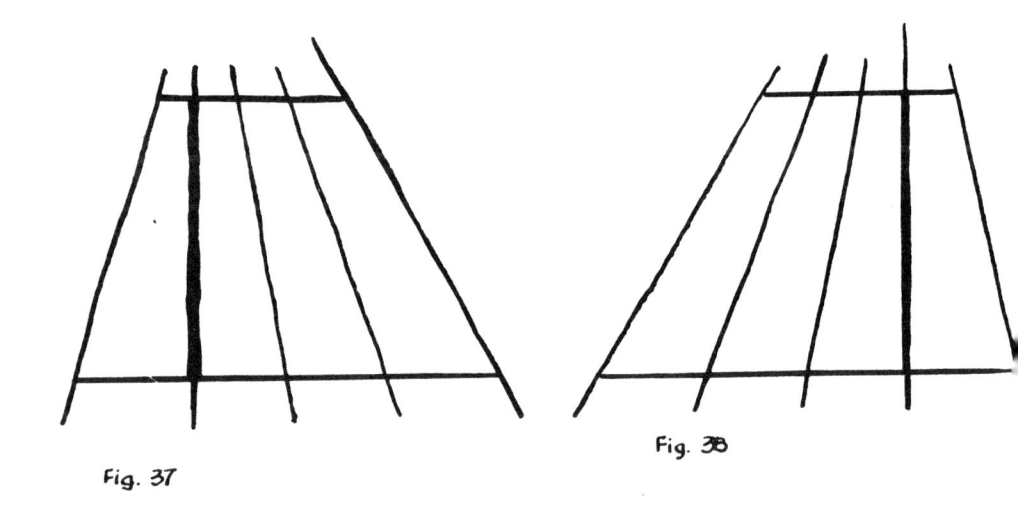

Fig. 38

Fig. 37

The vertical signifies the logical direction on a plane.

19 Horizontality.

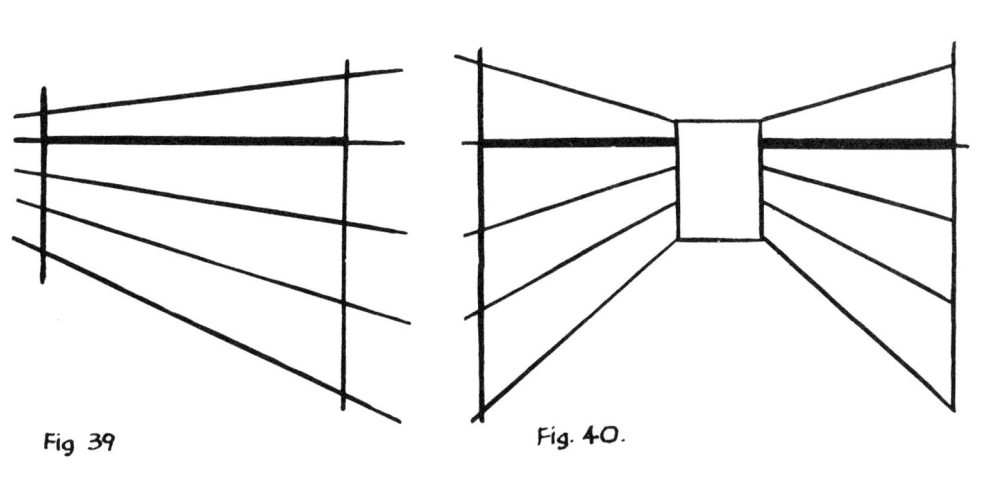

Fig 39 Fig. 40.

The horizontal signifies the proportionate height of the subject.

A line connecting all spatial points, lying on eye level, is called the eye-line.

Proof of the statement about the horizontal.

Fig. 41

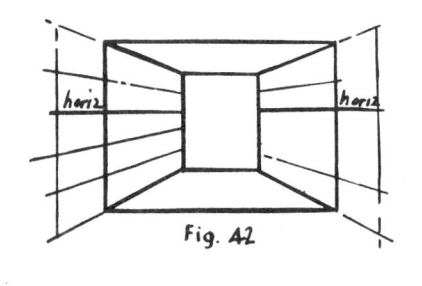

Fig. 42

Fig. 41: The inserted space box gives the subject a view of the **upper** plane; therefore this plane should lie below his eye level. Indeed, the horizontal is situated above.

Fig. 42: The inserted space box gives the subject a view of the **inside** plane; therefore this plane should lie above his eye-level. Indeed the horizontal line is below.

Fig. 43

Fig. 43: in this case, however, the eye sees the upper plane of the space box neither from above nor from below. The plane appears merely as a horizontal line. Consequently, it must lie exactly on eye-level. Indeed, the rim of the upper plane coincides with the horizontal.

40

20 **Once more the vertical.**

Why is Fig. 44 as representation of a house wall incorrect? It isn't wrong logically. The lower window openings are closer to the eye than the upper ones, which means they are "larger" perspectively. As representation of a floor pattern, this perspective rendering could be easily accepted. This picture therefore is not

Fig. 44

incorrect **logically**, but **psychologically**. Because every creature, in order to preserve his balance, insists on seeing actual verticals projected as such.

21

Fig. 45

Fig. 46

The tightrope walker with his pole. Horizontality. The Horizon as actuality.

Horizontality: The Horizon as supposition.

The **vertical indicates the straight path** and **the erect posture** or the **position** of the creature. The **horizontal** indicates his **height**, his **horizon**. Both are completely realistic, static facts.

The scale.

Fig. 47

The tightrope walker is emphatically concerned about his balance. He calculates the gravity on both ends. He is the scale.

The essence of the scale is the crossing of perpendicular and horizontal.

Disturbed balance and its effect.

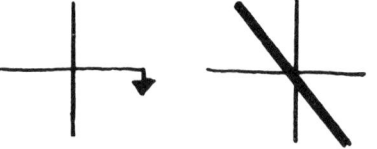

Correction through counter-weight, and the resulting counter-effect.

Combination of both effects, or diagonal cross (symmetrical balance as restoration).

42

(23) Non-symmetrical balance.

(Symbol):

Fig. 48

Disturbed Balance	**Restored Balance**

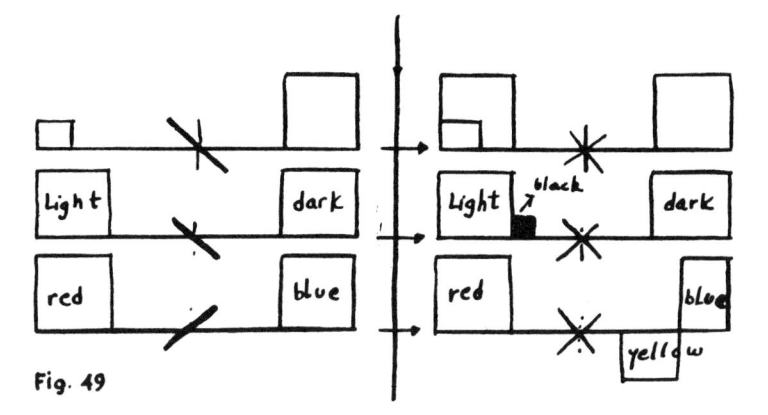

a) Metric:

b) Weight:

c) Character:

Fig. 49

Diagramatic presentation to **Fig. 23.**

Fig. 50a: Overloaded through the heavy dark, the axis AB has dropped from a to A, and has risen from b to B. Its original horizontal position was ab. Both axes, ab and AB, have the point C has a common pivot. As the result of a turn around this point, left-dark is now lower than right-light. To restore balance, black is added to the right-light.

Or: I am stumbling toward left and reach out toward right to prevent a fall.

Fig. 50b: The upper portion of my body is too heavy. The vertical axis shifts toward left and I would fall if correction would not take place in time by broadening the base through a step outward of my left leg.

⑳ Building a tower.

Fig. 51: Stone I rests on the foundation stone. This upsets the balance toward left. To equalize, and causing a new disturbance, stone II is added to the right. Following this pattern, stone III pulls toward left, stone IV equalizes and pulls toward right, etc., until finally the keystone establishes a definitive equilibrium.

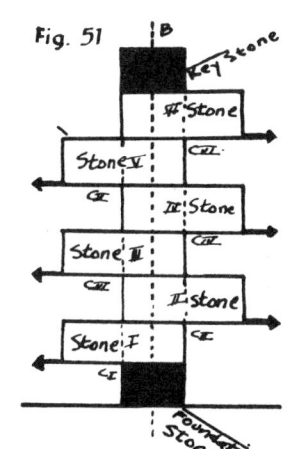

Fig. 51

Fig. 52: P₁, P₂, P₃, etc., are the pivot points of the toppling stones. Connected with each other by a line, they form a zig-zag pattern that circumscribes the vertical axis.

Fig. 52

45

III.

26 EARTH, WATER AND AIR.

Symbols of the static area are plummet (position) and balance.
The plummet aims at the earth center where all materially-bound
existence is anchored.

But there are regions with different laws and new symbols, signifying
freer movement and dynamic position.

Water and atmosphere are transitional regions.

Fig. 53

 AIR

 EARTH (mountain).

Fig. 54: A bullet, fired at a steep angle, rises with diminishing energy into the air; it **turns,** and falls to earth with accelerated energy.

(Loose continuity.)

Fig. 54.

Fig. 55

Fig. 55: A climber of stairs, ascending with increasing energy from step to step.

(Rigid continuity.)

 WATER

Fig. 56

The leg strokes of a swimmer—rhythm in loose continuity.

III. ③⁰ ③¹ ③²

③⁰

EARTH (mountain) and AIR combined.

Loose motion ⌐ Solid

Loose motion ⌐ Solid
⟨Hard Resonance⟩

Loose — Solid —
⟨Hard Resonance⟩

Loose — Solid —
⟨Hard Resonance⟩

Solid. **Fig 57**

A stone falls. Increasing in acceleration, it bounces down a steep hill.

(Continuity partly loose, partly rigid.)

Fig. 59: A meteor moves along its orbit. Attracted by the earth, it is deflected from its course and traverses the earth's atmosphere.
As shooting star, it barely escapes the peril to be tied forever to the earth, and moves on into the stratosphere, gradually cooling off and extinguishing. (Loose continuity.)

③¹ AIR

very warm

Less warm

Cool

warm

warm

Fig. 58.

A balloon rises from a warm into a cool air stratum, then into a somewhat warmer and finally into a very warm region.

(Loose continuity.)

③² Cosmic and atmospheric combined.

Meteor

Fig. 59

III. ③③

Symbols of form in motion.

③③ The spinning top.

A scale, deprived of its material support, and reduced to one point of contact, will topple and fall, even if its weight has been carefully distributed (Fig. 60):

Fig. 60

Fig. 61

Horizontal gyration will save this toy from falling.

This is the principle of the spinning top. (Fig. 61.)

A double top will even dance on a taut string without falling (Fig. 62).

Fig. 62

51

(34) The pendulum.

The plumb is transformed into a pendulum by swinging it back and forth.

Fig. 63

Fig. 63a.

Motion and counter-motion of the pendulum resu in equilibration of movement (Fig. 64).
Or: motion path of the pendulum with static fixa tion point (Fig. 65).

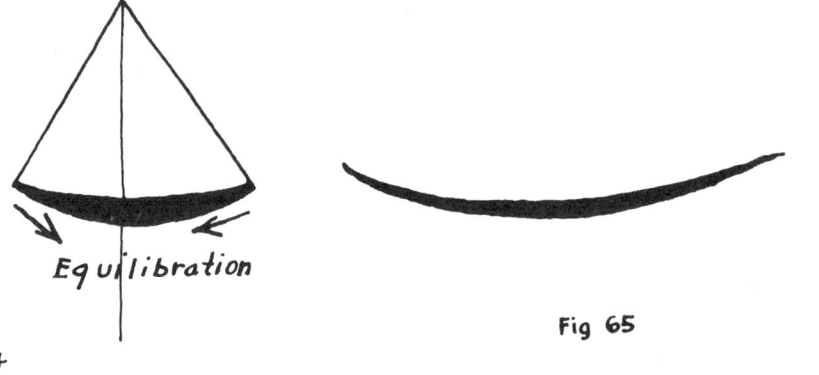

Equilibration

Fig. 64

Fig 65

35 The Circle.

This latter form (Fig. 65) can be expanded through increased motion at the fixed guidance point of the pendulum. The observable significance of such a form contiunity, originating at the guidance point, is transposed into larger mobile forms. The purest mobile form, the cosmic one, however, is only created through the liquidation of gravity (through elimination of material ties).

This moment (Fig. 66) is imagined as occurring while the pendulum is in full swing. It will circumscribe a circle which is the purest of mobile forms.

The necessity for a back and forth motion of the pendulum from a fixed point has been eliminated The newly created form (Fig. 66a) remains the same whether the motion starts from left toward right, or from right toward left.

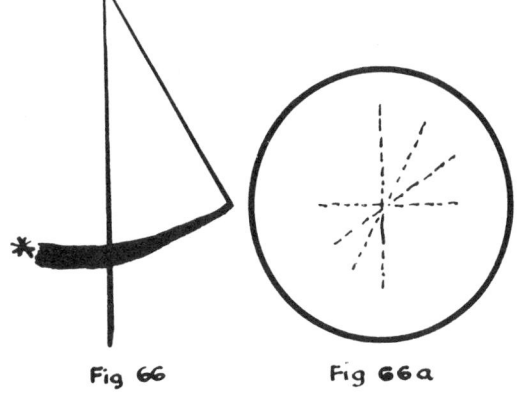

Fig 66 Fig 66a

36 The Spiral.

Changing length of the radius, combined with peripheral motion, transforms the circle into the spiral. Lengthening of the radius creates a vibrant spiral. Shortening of the radius narrows the curve more and more, till the lovely spectacle dies suddenly in the static center. Motion here is no longer finite; and the question of direction regains new importance. This direction determines either a gradual liberation from the center through freer and freer motions, or an increasing dependence on an eventually destructive center.

This is the question of life and death; and the decision rests with the small arrow (Fig. 67).

Fig. 67

53

(37) The Arrow.

The father of the arrow is the thought: how do I expand my reach?
Over this river? This lake? That mountain ?

The contrast between man's ideological capacity to move at random
through material and metaphysical spaces and his physical limitations, is

Thither !

Fig. 68

the origin of all human tragedy.
It is this contrast between power
and prostration that implies the

duality of human existence. Half winged—half imprisoned, this is man

Thought is the mediary between
earth and world. The broader the
magnitude of his reach, the more
painful man's tragic limitation. To
be impelled toward motion and
not to be the motor! Action bears
this out.

there liberation

Thither !

Here Restriction

Fig 69

How does the arrow overcome the hindering friction? Never quite to
get where motion is interminate.
Revelation: that nothing that has a start can have infinity.
Consolation: a bit farther than customary!—than possible?
Be winged arrows, aiming at fulfillment and goal, even though you
will tire without having reached the mark.
An actual arrow consists of shaft

(38)

 point
 feathering
 (rudder)

The symbolic arrow is direction
 with point
 and feathering
 combined as
 point-rudder.

Fig. 70

Fig. 71

Equal length of the point-rudder and equal
degrees of the point-rudder from the shaft,
result in straight flight (Fig. 71: $a=b; \alpha=\beta$).

(38) (THE ARROW)

Uneven lengths and uneven angle-degrees of the point-rudder result in a deviating course (Fig. 72).

$a < b$ $\Big]$ ascending
$\alpha < \beta$ $\Big]$ course.

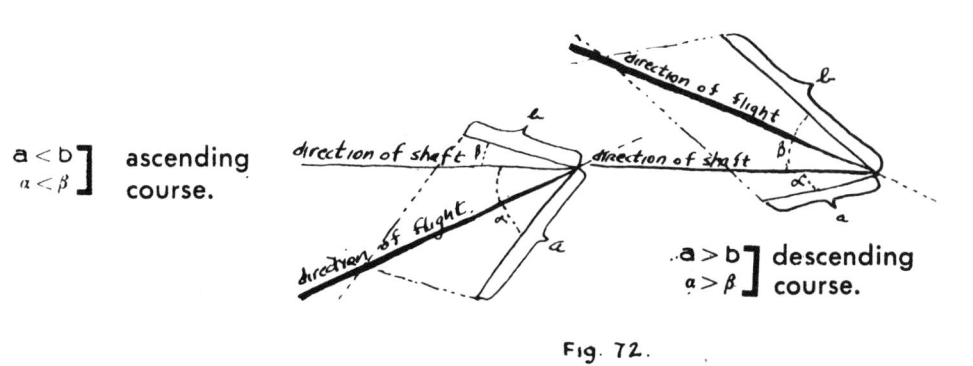

$a > b$ $\Big]$ descending
$\alpha > \beta$ $\Big]$ course.

Fig. 72.

The stronger the pull of the ascension rudder, the higher the rise;

the stronger the pull of the drop rudder, the steeper the descent.

Fig 73.

55

Fig. 74: In the world of physical reality every ascent must be followed by a descent at the moment at which the gravitational pull of the earth overcomes the ascending energy of the rudder. The physical curve thus ends as a perpendicular line (theoretically in the center of the earth).

In contrast to Fig. 74 a cosmic curve frees itself more and more from the earth in infinite motion, to fulfill itself freely in a circle or at least an elipse.

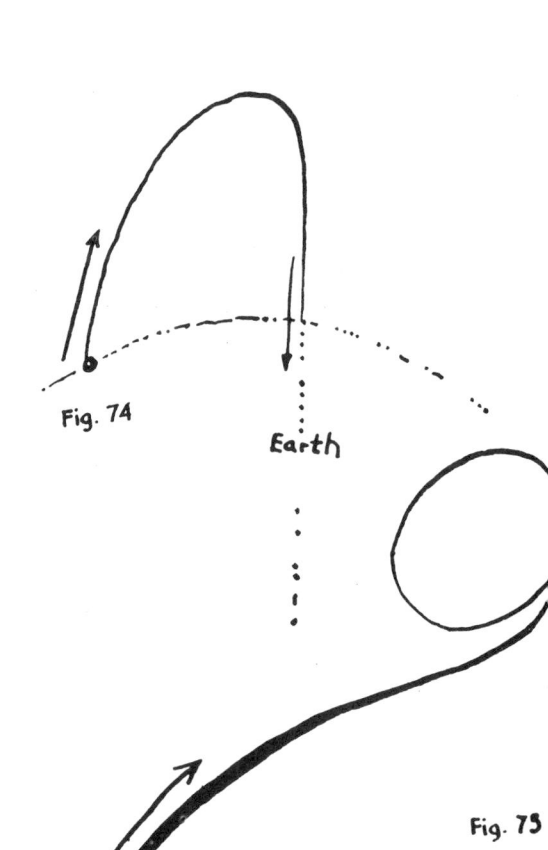

Fig. 74

Earth

Fig. 75

Earth

40 Formation of the Black Arrow
(Fig. 76).

Black End

Black Origin

White in white

Fig. 76

This arrow forms when a given, or adequate, or actual white receives intensified energies from additive, acting, or futural black. Why not the other way around? Answer: The stress lies on rare specialty as against broad generality. The latter affects us as competently static and customary; the first one as unusual, activating. And the arrow always flies in the direction of action.

In a well-arranged equilibrium of both characteristics, the direction of movement manifests itself so forcefully that the ambiguous symbol (arrow) may be eliminated.

The given white, much-too-much-seen and tiresome white, is noticed by the eye with little sensation; but the contrasting peculiarity of sudden action (black) sharpens the vividness of vision toward the climax or the termination of this action.

This extraordinary increase in energy (in a productive sense) or of energy food (in a receptive sense) is decisive for the direction of movement.

The **black arrow**
(diagram of
formation).

given: white

given white ———→ added: some black more and total black

given: white

white | black | culmination Fig. 77 a

The **red arrow**.

given: white

given: red deficiency

given red·
deficiency ———→ added: some red | more red | total red

given red deficiency

white | red deficiency | red culmination Fig. 77 b

The **hot arrow**.

Caloric arrow from
heat to combustion.

given water

given water ———→ added: from water | to vapor | to fire

given water

red deficiency | water | blaze culmination Fig. 77 c

The **cold arrow**.

Extinguishing
a blaze.

given water

given blaze

given blaze ———→ added: from fire | to vapor | to water

given blaze

water | blaze | ice culmination Fig. 77 d

The **green-red arrow**.

Chromatic.

given : green

added : red

from green | to gray | to red

green

Fig. 78

The **red-green arrow**.

Chromatic.

given : red

added : green

from red | to gray | to green

red

given : green

Fig. 79

Table of chromatic
incandescence
(mainly blue-orange).

Table of chromatic
cooling
(mainly orange-blue).

given : cold	from green	to grey	to red
	from blue	to "	to orange
	from violet	to "	to yellow

Fig 80

given : hot	from red	to grey	to green
	from orange	to "	to blue
	from yellow	to "	to violet

Fig. 81

42 ## The organization of movement.

The preceding diagrams (Figs. 76-81) are suggestions for the rendering
of mobile factors in composition. The composition itself: kinetic co-
ordination is an intricate task and demands a concept of advanced
maturity. As norm for such a composition we may postulate: a har-
monization of elements toward an independent, calm-dynamic, and
dynamic-calm entity. This composition can only be complete if move-
ment is met by counter-movement or if a solution of kinetic infinity has
been found. (To the first case see Fig. 82; also Fig. 65.)

Fig 82

(43) The infinite movement, chromatic.

Passing on to infinite movement, where the actual direction of movement becomes irrelevant, I first eliminate the arrow. Through this act heating and cooling-off, for instance, become one. Pathos (or tragedy) turns into ethos which encompasses energy and counter-energy within itself.

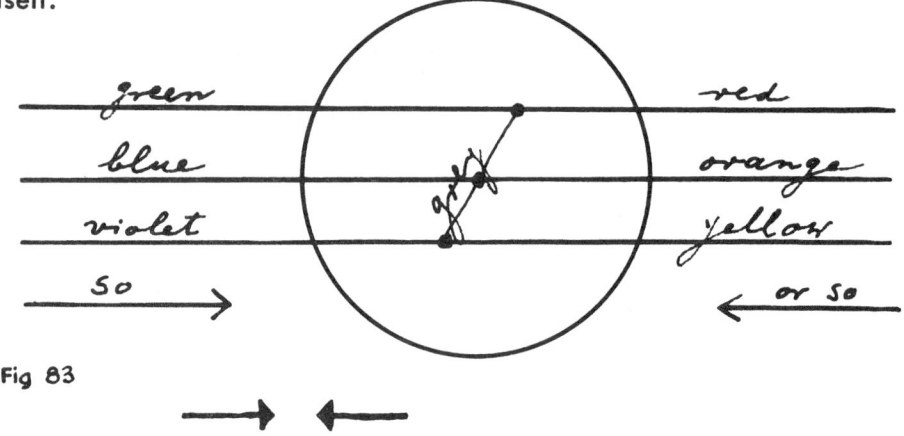

Fig 83

At first, movement and counter-movement: so→ or ←so. In this way a center is prepared—the central grey (Fig. 83).

The purer the presentation of the grey, the narrower its reach, theoretically confined to a mere point.

Fig. 84

Left of the grey point, green is in the ascendancy; right, close to the grey point, already red. Consequently one could be tempted to arrive at the following diagram (Fig. 85):

60

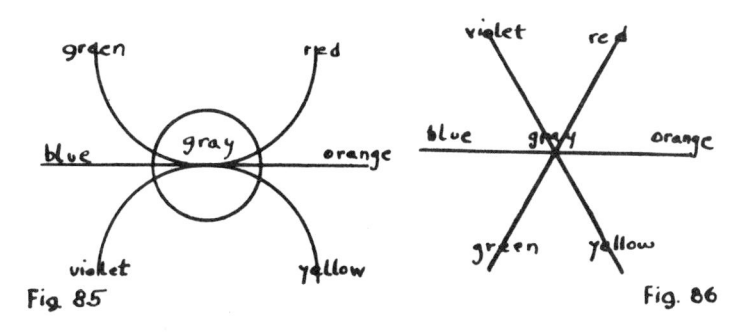

Fig. 85 Fig. 86

It is, however, not logical to bring the steps green-red and violet-yellow in contrast to blue-orange (Fig. 85). Therefore a diagonal presentation of the main scale is indicated (Fig. 86).

We have arrived at the spectral color circle where all the arrows are superfluous. Because the question is no longer: "to move there" but to be "everywhere" and consequently also "There!"

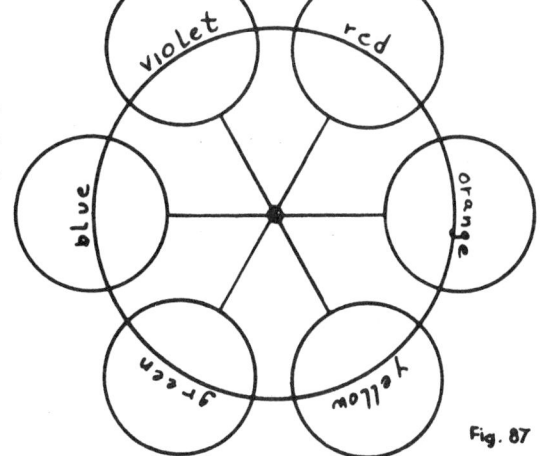

Fig. 87

A concluding note

The beacon, guiding Klee through his adventures in seeing, is the line in action. The dot, extended into a graphic curve, cannot come to rest on the last page of the Sketchbook. It urges on to further explorations, both in space and spirit. For the teacher who wants to respond to this incentive, a complete program is indicated in the four subdivisions:

I:
Line as point progression
Line as planar definition
Line as mathematical proportion
Line as coordinator for the path of motion

II:
Line as optical guide
Line as optical reason
Line as psychological balance

III:
Line as energy projection

IV:
Line as symbol of centrifugal and centripedal movement
Line as symbol of will and infinity
Line as symbol of color mutations and kinetic harmony

There are endless phenomena all around us on which to aim Klee's ideas like a searchlight. The "line on a walk" can produce new rhythmic curves. Any surface offers itself for definition through line-connected points. Klee's examples of coordinated linear motion: bone and muscle, blood stream, waterfall, can be supplemented by the vertical extension of bird flight, the horizontal motion of the tides, the circular rhythm of tree rings. The optical perceptions and illusions of each student form the framework of his security. But has he observed their pattern as they relate him to the experiences of physical height, spatial distance, forward motion, light and dark contrasts? What does he actually see and what are the optical facts? And there is the intimate and instinctual identification of object and meaning which Klee defines through the two arrows, the spinning top, the shooting star. Many other examples can

widen the theme: Lightning, for instance, as scientific and as emotional experience, or the path of an eclipse, the swing on its rope hooks—free and confined at the same time, the forward dash of sail and prow. These are mere hints, pointing toward a use of Klee's book that will, in the words of Novalis:

> " . . . give sense to the vulgar,
> give mysteriousness to the common,
> give the dignity of the unknown to the obvious,
> and a trace of infinity to the temporal."

S. M-N.

PRAEGER PAPERBACKS

PEDAGOGICAL SKETCHBOOK

BY PAUL KLEE

INTRODUCTION AND TRANSLATION BY SIBYL MOHOLY-NAGY

87 illustrations

Paul Klee occupies 'a unique position among the creators of modern art. Although he shed all ties with conventional presentation, he developed a closer and deeper relationship to reality than did most painters of his time. Without any attempt at imitation or idealization, he recorded proportion, motion, and depth in space as the fundamental attributes of the visual world.

Klee collected his observations in his PEDAGOGICAL SKETCH-BOOK, intended as the basis for the course in design theory at the famous Bauhaus art school in Germany. From the simple phenomenon of interweaving lines, his work leads to the comprehension of defined planes—of structure, dimension, equilibrium, and motion. But he employs no abstract formulas. The student remains in the familiar world—a world that acquires new significance through the straightforward approach of Klee's simple, lucid drawings and his precise captions. Chessboard, bone, muscle, heart, a water wheel, a plant, railroad ties, a tightrope walker—these serve as examples for the forty-three design lessons.

PEDAGOGICAL SKETCHBOOK is a vital contribution toward a more human, more universal goal in design education—the work of a visionary painter who dedicated himself to the practical task of making people see.

"A key to understanding of the art of Paul Klee, one which can be used most profitably by the art student."—*College Art Journal.*

SIBYL MOHOLY-NAGY, who is Associate Professor of Architecture at Pratt Institute, has prepared this new translation, following Klee's text with the utmost fidelity.

FREDERICK A. PRAEGER, *Publishers*

111 Fourth Avenue, New York, N.Y. 10003